CATS & BOOKS

First published in the United States of America in 2022 by
Rizzoli International Publications, Inc.
300 Park Avenue South
New York, NY 10010
www.rizzoliusa.com

Copyright © 2022 Rizzoli International Publications, Inc.

Publisher: Charles Miers
Editors: Jennifer Thompson and Nikki Maldonado
Design: Celina Carvalho
Production Manager: Colin Hough Trapp
Managing Editor: Lynn Scrabis

Printed in China

2022 2023 2024 2025 2026 / 10 9 8 7 6 5 4 3 2 1

ISBN: 978-0-7893-4118-1
Library of Congress Control Number: 2021938208

Visit us Online:
Facebook.com/RizzoliNewYork
Twitter: @Rizzoli_Books
Instagram.com/RizzoliBooks
Pinterest.com/RizzoliBooks
Youtube.com/user/RizzoliNY
Issuu.com/Rizzoli

CATS & BOOKS

RIZZOLI
NEW YORK

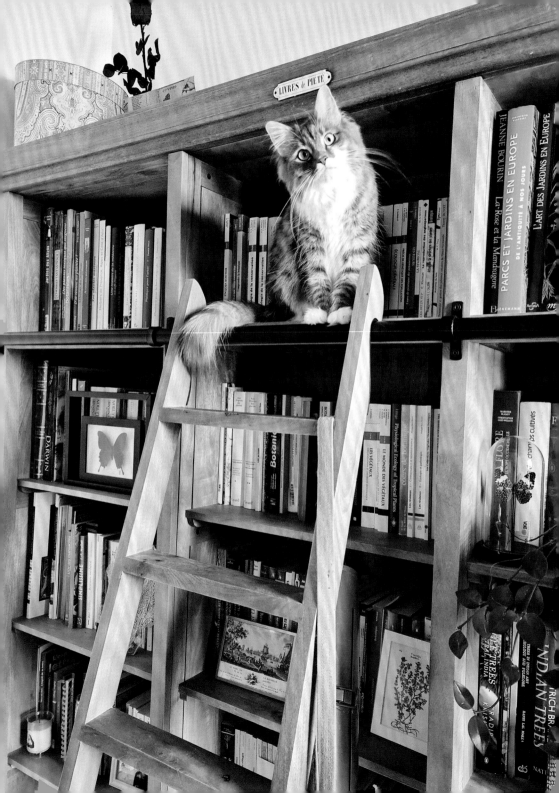

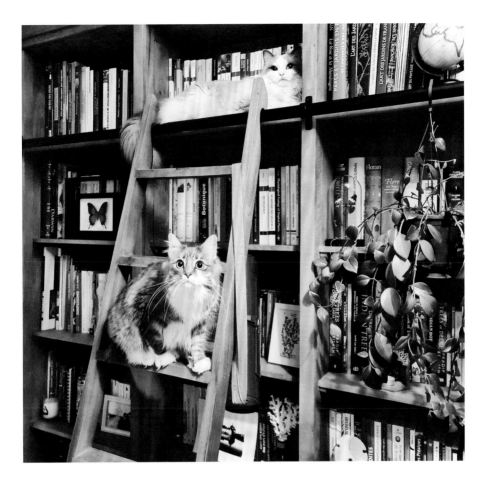

OLYMPE & DARWIN

Châlons-en-Champagne, Marne, France

- Olympe and Darwin love to nest in the library.

- Their favorite spot is on the top shelf. This makes my rare books librarian self very satisfied.

DARWIN

Châlons-en-Champagne,
Marne, France

- Darwin is the very first cat I owned, and we have the most special bond.

- He's a typical Ragdoll cat: incredible blue eyes; softest fluff; a docile, calm, gentle, and floppy nature.

- He loves his routine, and a quiet environment, which makes him the best reading buddy!

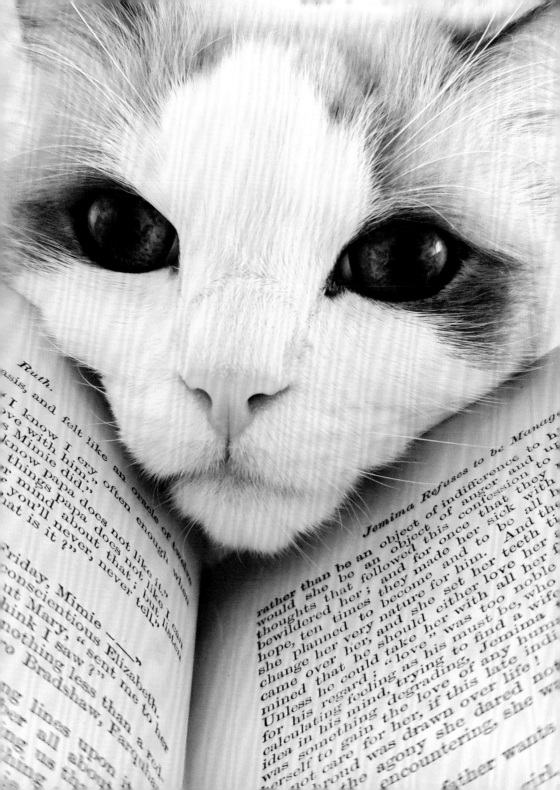

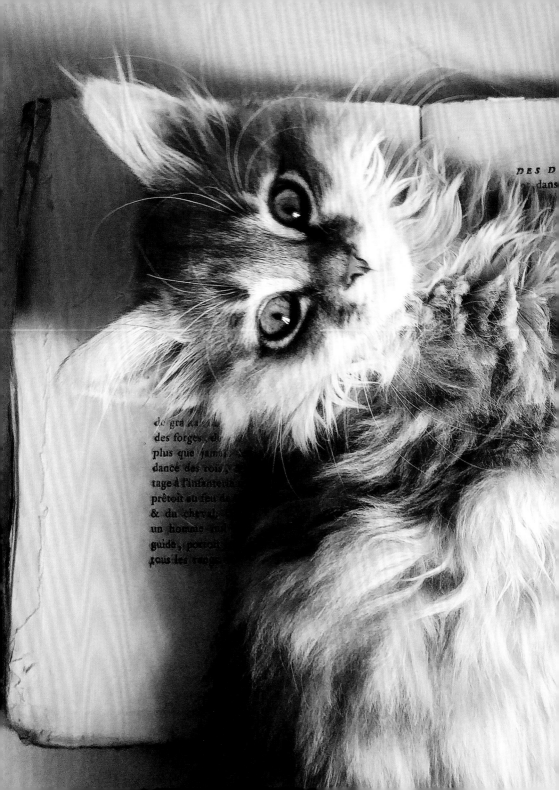

OLYMPE
Châlons-en-Champagne,
Marne, France

- Olympe is my second cat. I adopted her when she was about two months old from a foster home.

- My first cat, a male, was three at the time of her adoption and acted like a mother to her. He even let Olympe suckle—not for milk obviously but for emotional well-being—which was absolutely lovely to witness.

- Olympe was named after the eighteenth-century French writer and feminist activist Olympe de Gouges.

Mais
ns , ils les
gion gagna
oiffoit le feul
fion , le feul
ns.
-tout des con-
fcipliner une
commençoit à

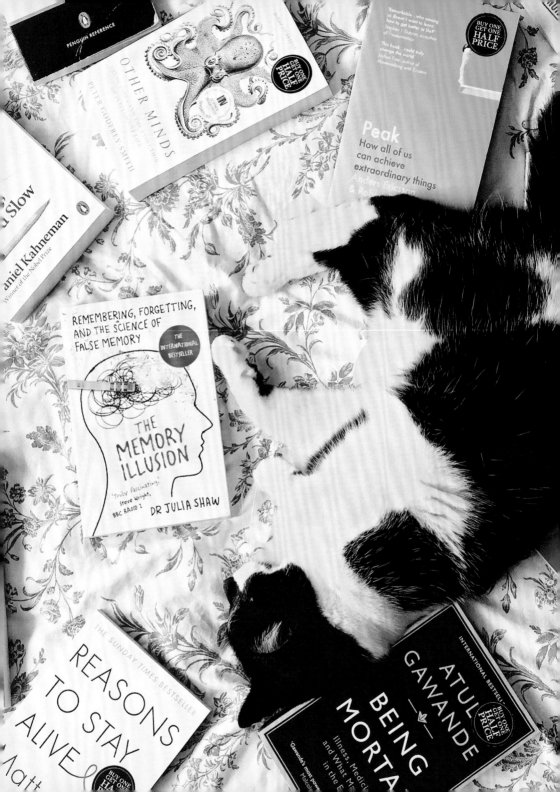

OLLY
Greater Manchester, UK

- He was incredibly heavy footed (you could hear him stomp downstairs and jump off furniture).

- He liked *not-so-quiet* midnight strolls in and out of bedroom windows (and would headbutt the door when he couldn't get in).

- He loved cuddles, but he had to get to know you very well first (and you knew when he had had enough).

- He enjoyed chasing our dog, Romeo, around the house.

- His favorite food was salmon.

- He was a rescue cat.

FELIX, ALSO KNOWN AS FELIX FELICIS
Melbourne, Victoria, Australia

- Felix, also known as Felix Felicis, is part of the Instagram dumblepaws_army. His furrmily includes Hermione, Sirius Grey, and Charlie Weasley.

- Felix was previously a stray cat that was living on the streets of suburbia in Melbourne, Australia. He has since been neutered, given a microchip, and vaccinated in what was described by the vets as an "unmanageable" situation.

- But those days have long gone and Felix is the smoochiest kitty and loves to hang out in the library spying on the other kits!

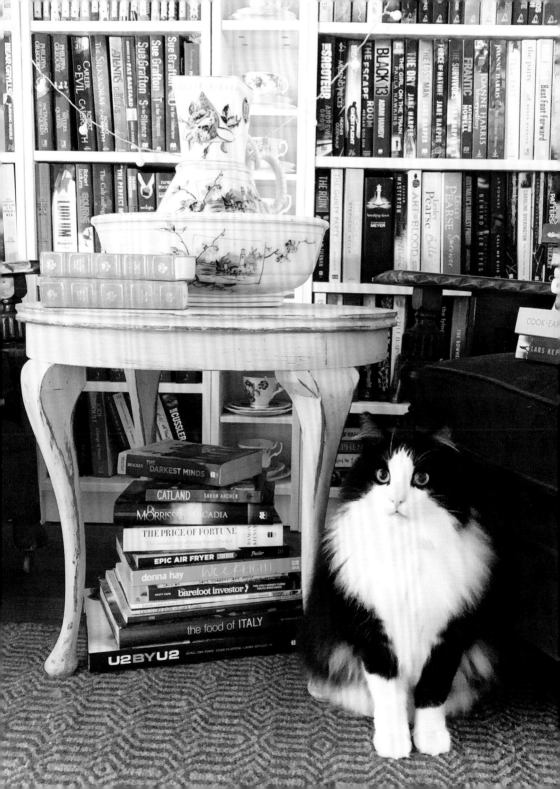

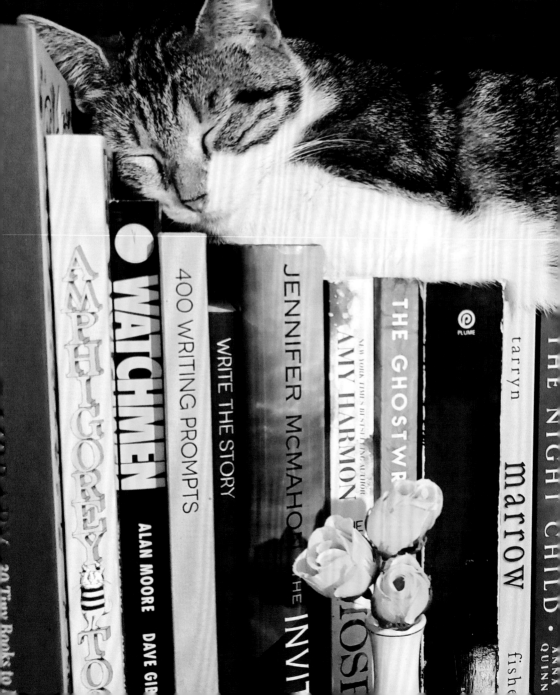

SCOUT
On top of Mama's Books, USA

- She was named after Scout Finch from *To Kill a Mockingbird*.

- She's a rescue kitty.

- She loves watching bugs and geckos at the kitchen window.

- She likes to play fight with her big bro.

- She has such a fun personality, and she makes me laugh every day! I love her so much!

JETER
Massachusetts, USA

- Jeter was a stray cat wandering around his family's neighborhood in fall 2014. The Creedens tried to find his owner, but no luck, so he became a member of the family!

- He was named after Derek Jeter, the Yankees player, who had recently retired from baseball.

- He is a BIG boy, who loves fishing toys, chin scratches, and a nice box to play in!

- You can follow his adventures on Instagram, @jeter_isabigboi.

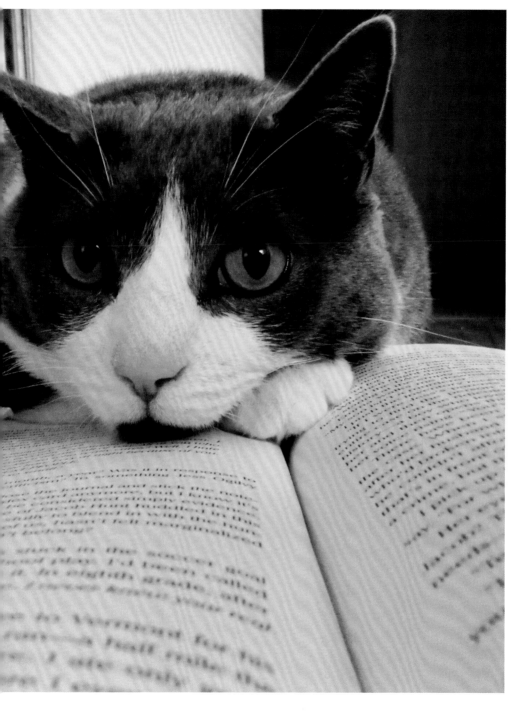

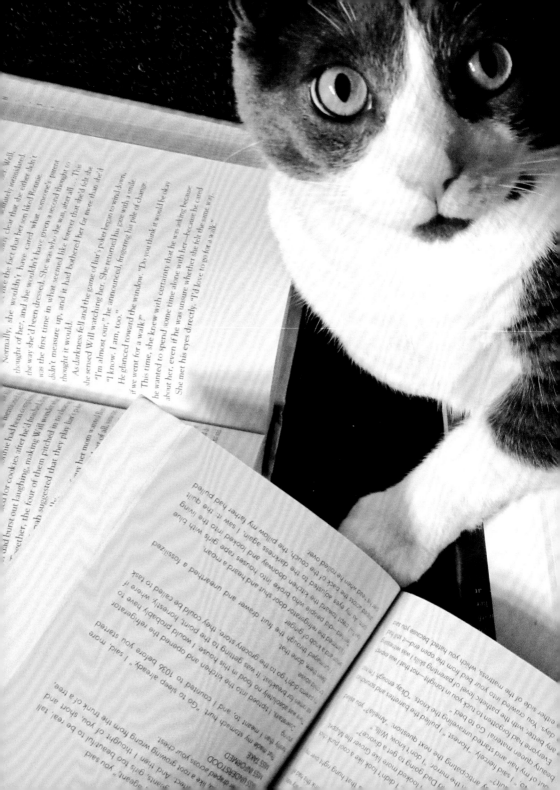

When we got into the car, she said, "I'm sorry."

Even though I didn't meet her gaze, I could feel her looking at me.

"Don't ever do that to me again," I answered.

I have to fill out a form for visitors. I can't imagine who might want to come, so I write down my mother's name and my brother's name and our address, and their birth dates. I add Jess's name, too, although I know she can't visit, obviously, but I bet she would have wanted to.

Then a nurse examines me, taking my temperature and checking my pulse, just like at the doctor's office. When she asks me if I'm on any medication, I tell her yes, but she gets angry when I don't know the names of the supplements, when I can only tell her the colors, or the fact that it comes in a syringe.

Finally, I am taken to the place where I will be staying. The officer walks me down a hallway until we reach a booth. Inside, another officer pushes a button, and the metal door in front of us slides open. I am given another laundry bag, this one with two sheets and two blankets and a pillowcase.

The cells are on the left side of a hallway that has a metal grate instead of a floor. Each cell has two beds, a sink, a toilet, and a television inside it. Each cell also has two men inside. They look like the same people you would see on the street, except of course they have all done something bad.

Well, maybe not. After all, I'm here, too.

"You'll stay here for a week while you're evaluated," the officer says. "Based on your behavior, you might be moved to the minimum-security population." He nods at one cell, which, unlike the others, has a smaller window. "That's the shower," the officer says.

How am I supposed to make sure I shower first when there are so many other people around?

How am I going to brush my teeth when I don't have my toothbrush with me?

How will I take my shot in the morning, and my supplements?

As I think about these details, I feel myself starting to lose control.

It's not like a tsunami, although I'm sure that's what it looks like to someone on the outside. It's more like a packet of mail that's wrapped tight several times with a rubber band. When it snaps, the band stays in place—out of habit, or out of muscle memory, I don't know—and then one

[right page, partially obscured]

h hand starts moving a little, my [...]
[...] is dead and I am in jail and I missed CrimeBuster[...]
[...] he has a tic now that I can't stop.

[...] stop walking when we reach the cell at the end of the hallway [...] sweet home," the officer says. He unlocks the door to the cell a [...] for me to move inside.

[...] minute he locks the door again, I grab the bars. I can hear the lights [...] overhead.

[...] Cassidy and the Sundance Kid didn't go to jail; instead they [...] off a cliff. "Kid, the next time I say 'Let's go someplace like Bo-[...] matter, "let's go someplace like Bolivia."

[...] head hurts, and out of the corners of my eyes, I am seeing red. I [...] them, but the sounds are still there and my hands feel too big for my [...] and my skin is getting tighter. I picture it stretching so hard that it [...]

"Don't worry," a voice says. "You'll get used to it."
[...] around and hold my hands clutched in front of my chest, the wa[...] [...] to walk, sometimes when I wasn't concentrating on looking li[...] [...] else. I'd assumed the officer had put me in a special cell [...] [...] who have to be in jail but shouldn't really be. I had not realized t [...] everyone else, would have a roommate.

[...] wearing all his blue clothes plus his jacket and hat, pulled dow[...] [...] brows. "What's your name?"

[...] stare at his face without looking him in the eye. He has a mole c [...] cheek, and I have never liked people with moles. "I am Spartacus [...] his grip? Then I hope you're in here for killing your parents." H[...] [...] from the bunk and walks behind me. "How about I call you B[...] [...] ?" My hands grip the bars more tightly. "Let's get some [...] right, so that you and me, we get along. I get the bottom bunk. [...] to the exercise yard before you do. I pick the TV channel [...] with me, and I won't fuck with you."

[...] is a common behavior in dogs that [...] One will snap at the other until [...] to be obeyed.

[...] not a dog. Neith[...] [...] cheek is raised [...]

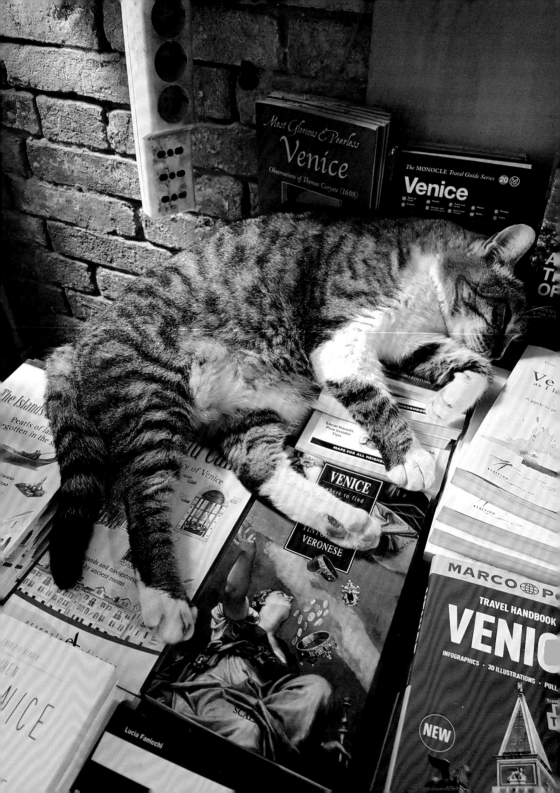

PEPE
Somewhere in Italy

- Our encounter was brief, but
 I gathered that Pepe is a
 true bibliophile.

- He didn't seem too keen on being
 petted, though, so is probably best
 admired from a respectful distance.

ROSIE COTTON
Steenwijk, the Netherlands

- Rosie is named after Sam's wife from *The Lord of the Rings*.

- Rosie knows how to sit on command.

- Rosie is always staring at people, which makes them uncomfortable.

- Rosie loves to play with her dog sister.

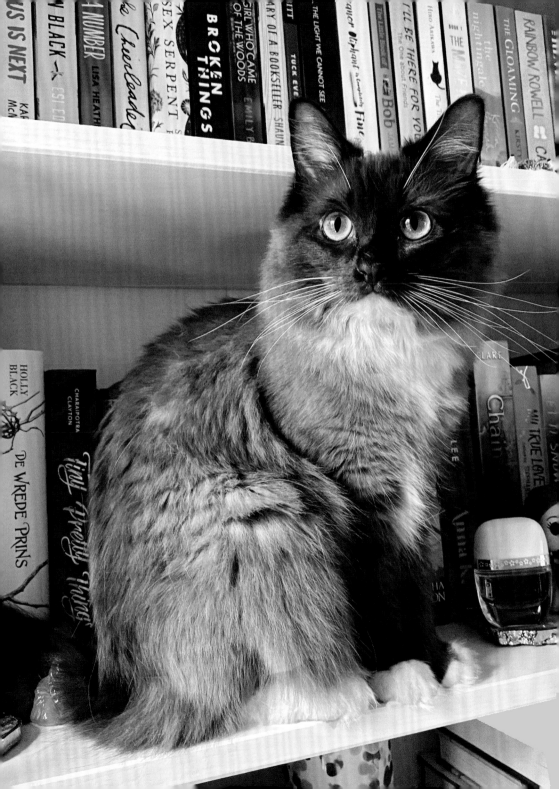

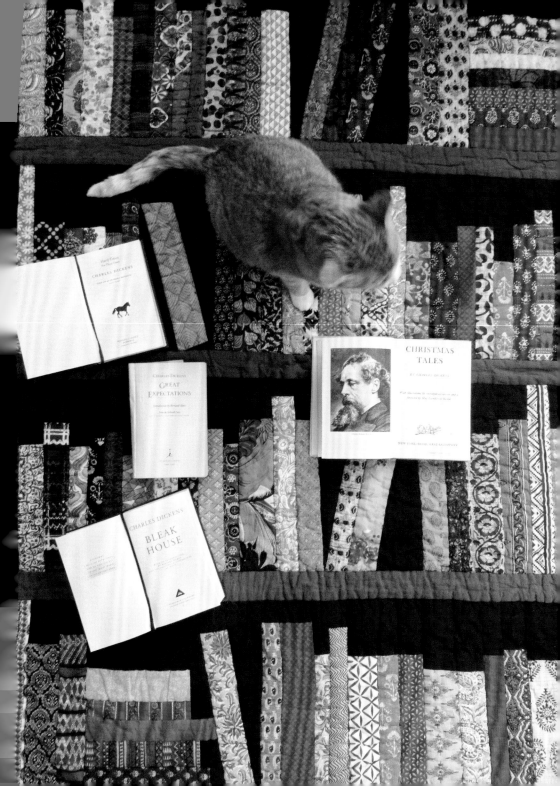

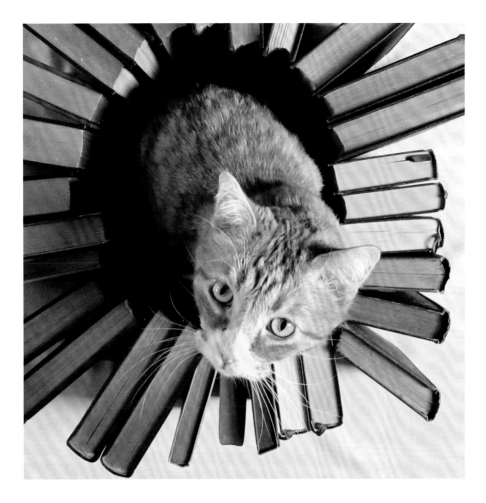

REMUS
Minnesota, USA

- Was a wounded stray cat meowing on the doorstep of two humans in a Minnesota winter.

- Named Remus after the infamous Prohibition-era lawyer and bootlegger George Remus.

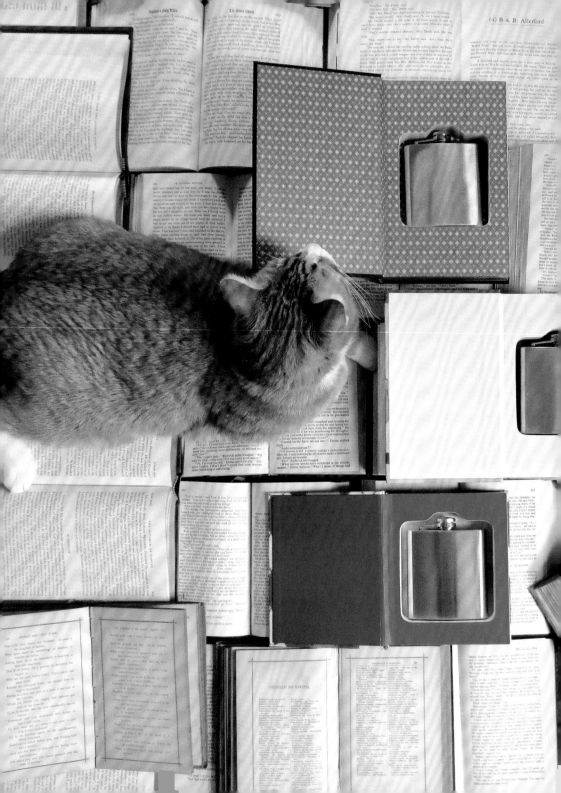

REMUS
Minnesota, USA

- Doesn't read but likes books having to do with orphans, such as Dickens novels.

- Sneaks out but also acquiesces to a leashed walk and tree-climbing watched by pet parents.

- Sleeps on the head of one of his humans, maybe because the human can purr like a mama cat.

TAYLOR
Living Room Sofa, USA

- Her owner was living at school when she got her as a tiny kitten back in 2002 and she snuck her into the dorm and Taylor spent her first couple months living there.

- She had the best meows and was the toughest and smartest kitty you could ever meet.

- She loved watching sports, chicken nuggets, her parents, but above all she loved being outside. She once broke out of the house's second story to go outside, and she used to accompany the family dog on walks.

- Unfortunately, Taylor passed away in November 2020; this photo was taken in March 2020 right before her eighteenth birthday—she was gorgeous her whole life. She will be forever missed.

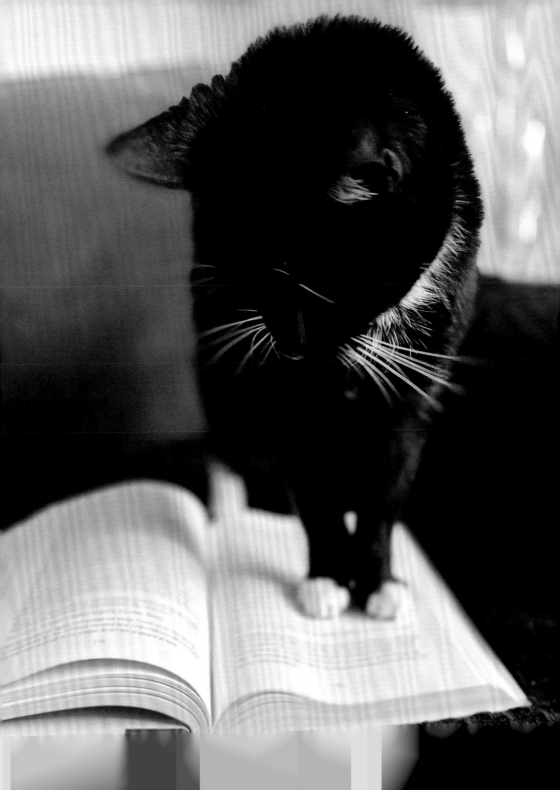

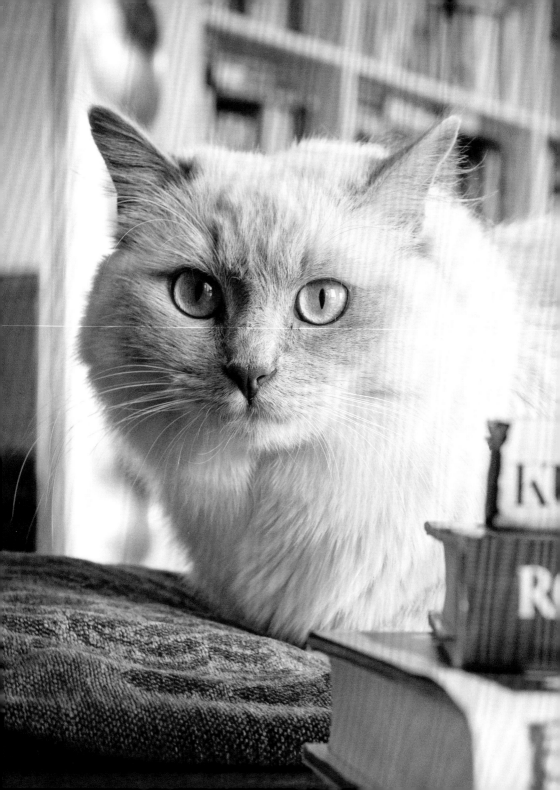

POSIE
New York, New York, USA

- Posie was picked up from the airport as a shy, three-month-old kitten.

- She is now a sassy two-year-old in constant need of pets and treats.

- Her hobbies include sitting on top of magazines and laptops, as well as swatting at shoelaces.

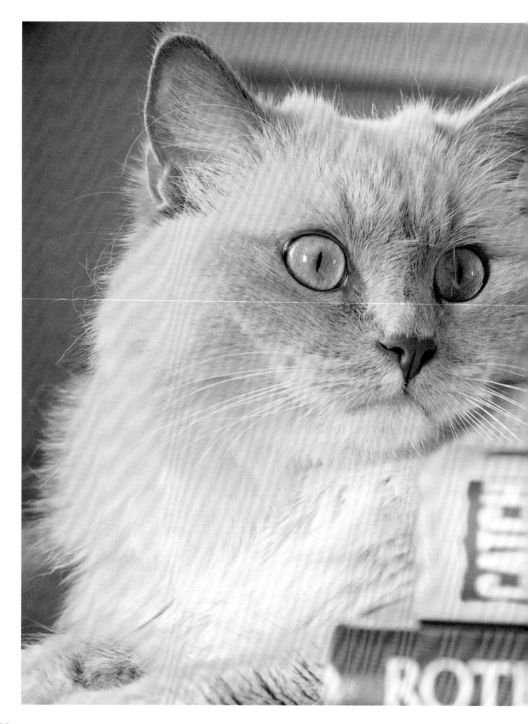

THE ANATOMY

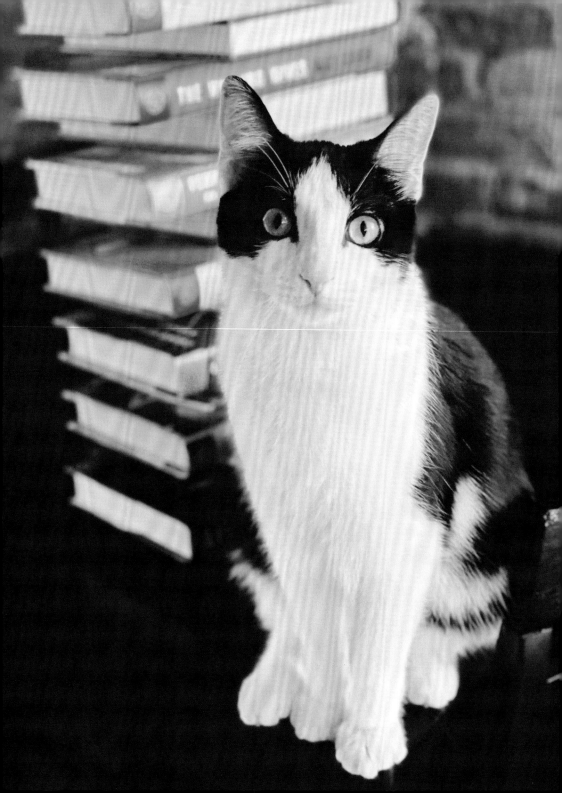

CATNISS
Grand Rapids, Michigan, USA

- Her name is Catniss because I adopted her in 2020 when we needed all the odds to be in our favor.

- Her favorite spot to sit is on top of my YETI cooler looking out the window.

CATNISS
Grand Rapids, Michigan, USA

- She LOVES plastic straws. They are her favorite toys.

- She knows how to open all the closets and cupboards in my house and often hides in them when I have company over.

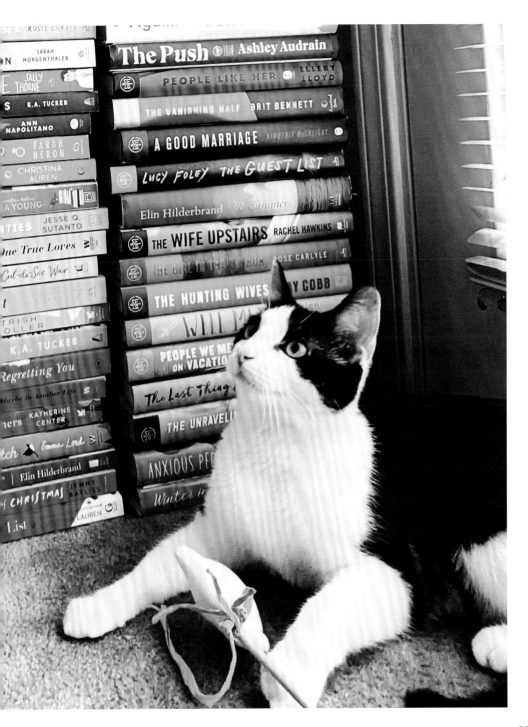

The Push ☐ Ashley Audrain
PEOPLE LIKE HER ☐ ELLERY LLOYD
THE VANISHING HALF BRIT BENNETT
A GOOD MARRIAGE KIMBERLY McCREIGHT
LUCY FOLEY THE GUEST LIST
Elin Hilderbrand 28 Summers
THE WIFE UPSTAIRS RACHEL HAWKINS
THE GIRL IN THE MIRROR ROSE CARLYLE
THE HUNTING WIVES MY COBB
WILL
PEOPLE WE MEET ON VACATION
The Last Thing
THE UNRAVELING
ANXIOUS PEOPLE
Winter in

ROSIE CURTIS
SARAH MORGENTHALER
SALLY THORNE
K.A. TUCKER
ANN NAPOLITANO
FARAH HERON
CHRISTINA LAUREN
A YOUNG
TIES JESSE Q. SUTANTO
One True Loves
Cul-de-Sac War
VERY JIMENEZ
TRISH DOLLER
K.A. TUCKER
Regretting You
Maybe in Another Life
KATHERINE CENTER
Emma Lord
Elin Hilderbrand
CHRISTMAS JENNY BAYLISS
LAUREN
List

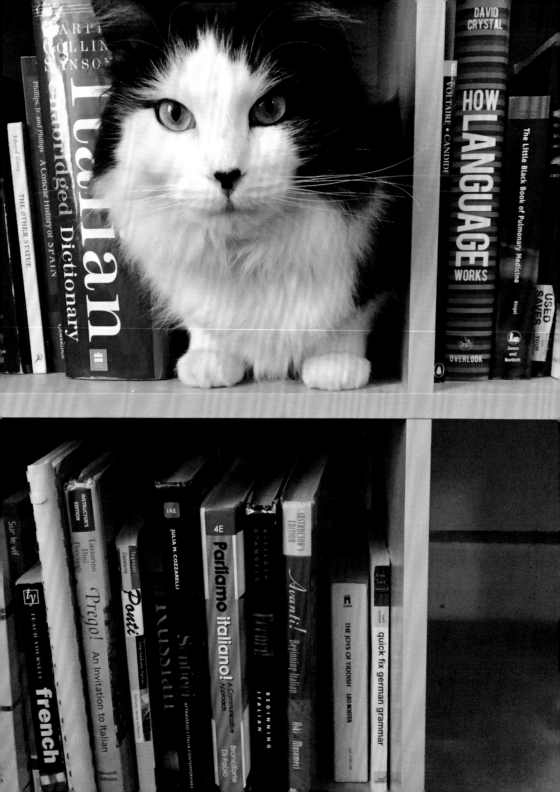

CAEDMON
New Haven, Connecticut, USA

- He's named after the earliest known English-language poet.

- He loves to burrow under blankets and every night he tucks himself under the covers with his humans.

- He loves to chase sticks, which we discovered when he started batting around a wooden chopstick that had fallen on the floor.

- His favorite treat is bonito flakes.

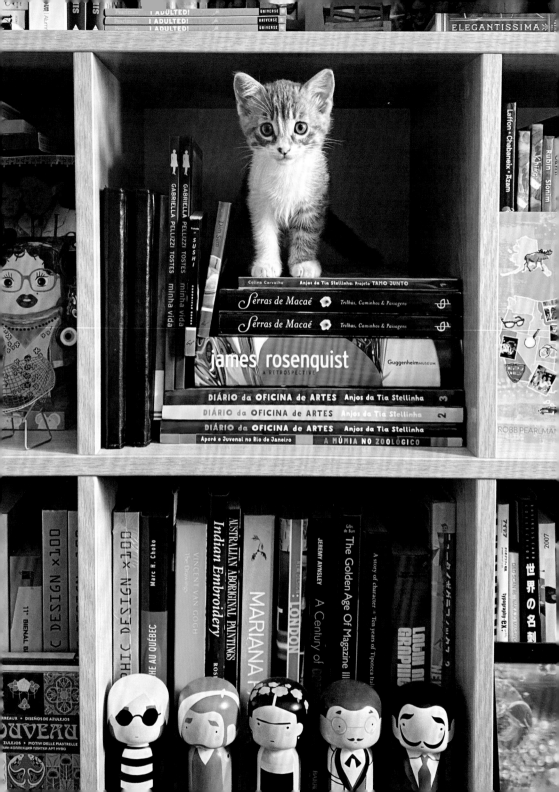

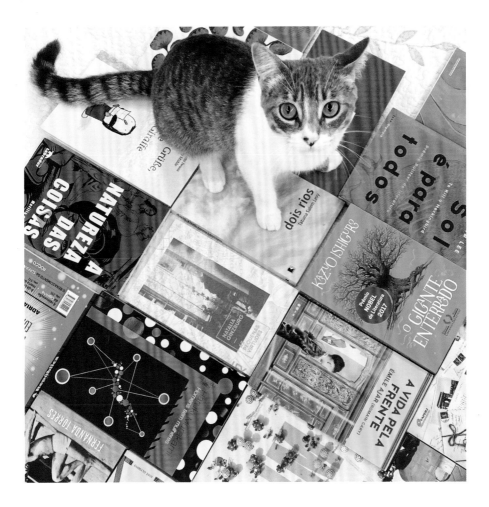

MILKY
Rio de Janeiro, Brazil

- Milky is our first and only cat. We adopted her when she was less than three months old.

- Her favorite thing to do is jump on my lap when I am working and take a good nap.

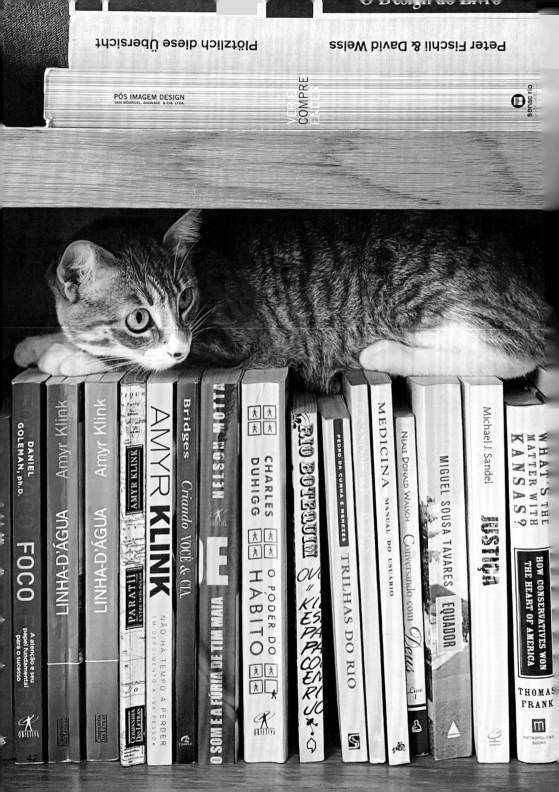

MILKY
Rio de Janeiro, Brazil

- Milky loves to play with colorful elastic bands.

- She loves to explore all corners of the house.

- Sometimes she goes inside the wardrobe unnoticed, and gets locked there for a while.

- Milky loves to chase birds and insects on the balcony.

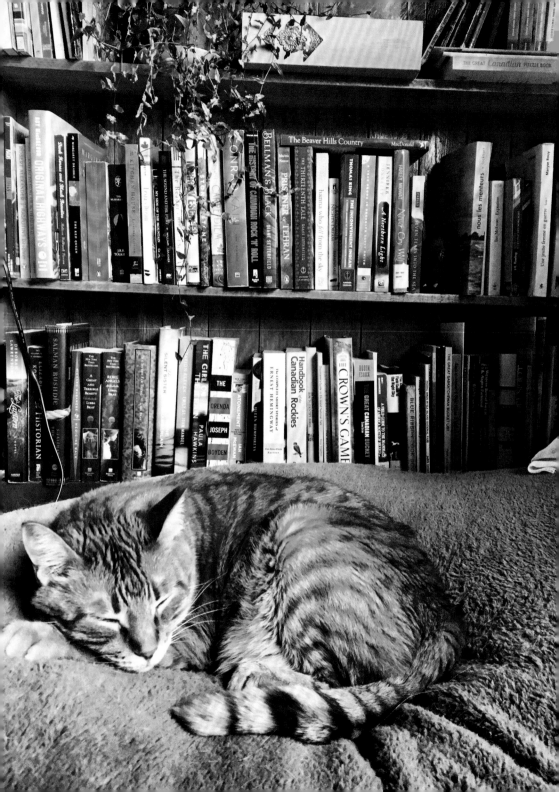

CHEDDAR
Alberta, Canada

- Farm cat turned house cat.

- Best alarm clock.

- Loves watching birds and squirrels.

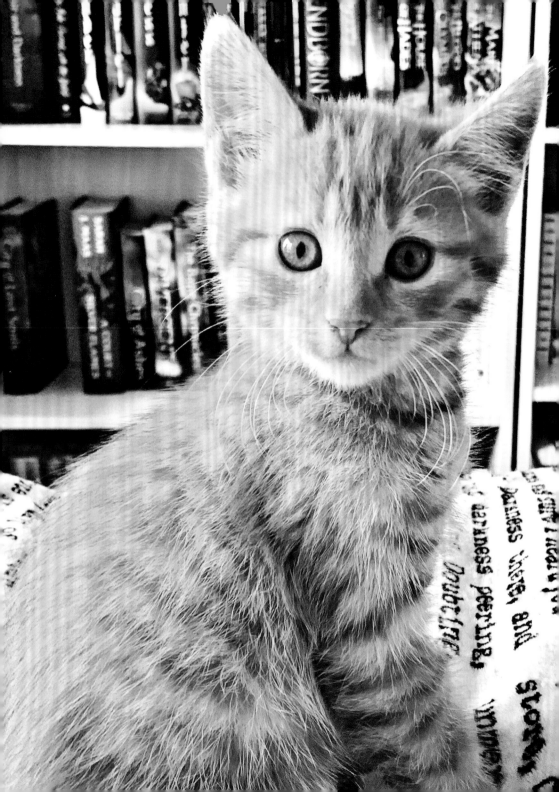

WAFFLES
Seattle, Washington, USA

- My birthday is on Easter.

- I'm an expert climber.

- I'm the baby of the family.

- I love milk even though my mom won't let me have it.

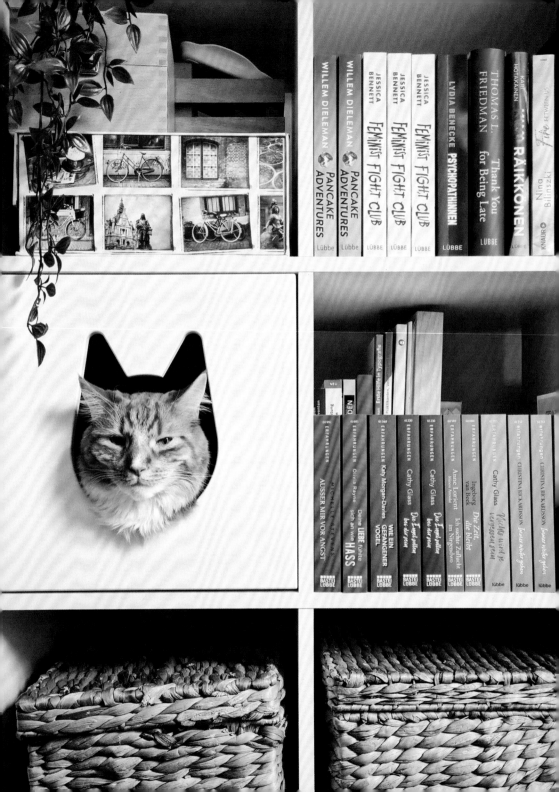

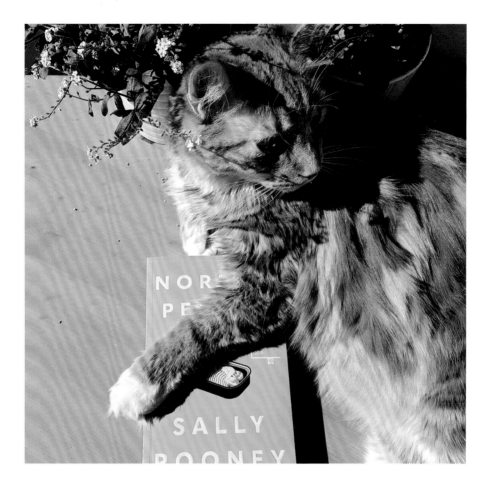

GEORGE
Düsseldorf, Germany

- George is a gentle soul and the best office buddy one could ask for.

- He is always purring and sleeping on the desk while his human works on the laptop. It's honestly the best and most soothing sound in the world.

GEORGE
Düsseldorf, Germany

- Loves ribbons, snacks, and belly rubs—hates being picked up and often hides behind book stacks (not very good at hiding, though, to be honest).

- Purrs a lot, especially if food is in sight, but also when his twin brother Fred cozies up next to him.

- If George is not napping on my desk, he loves napping in his little cat cave.

- I might be slightly biased, but I think that he has something regal about him and whenever he poses like this, I sort of understand why cats were worshipped as gods in ancient Egypt. Such grace, such beauty!

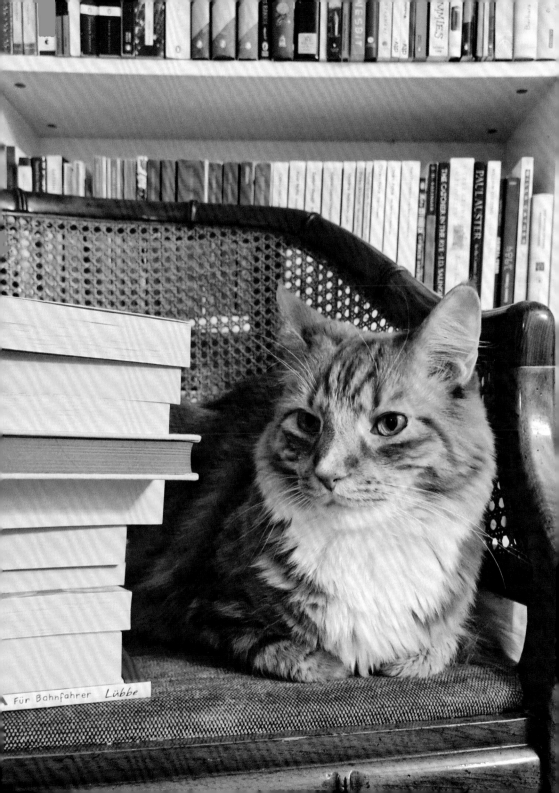

Für Bahnfahrer Lübbe

COOPER
Windsor, Ontario, Canada

- Cooper is very doglike.

- His favorite thing to do is look out open windows.

- He's very clumsy.

- He loves to have a conversation!

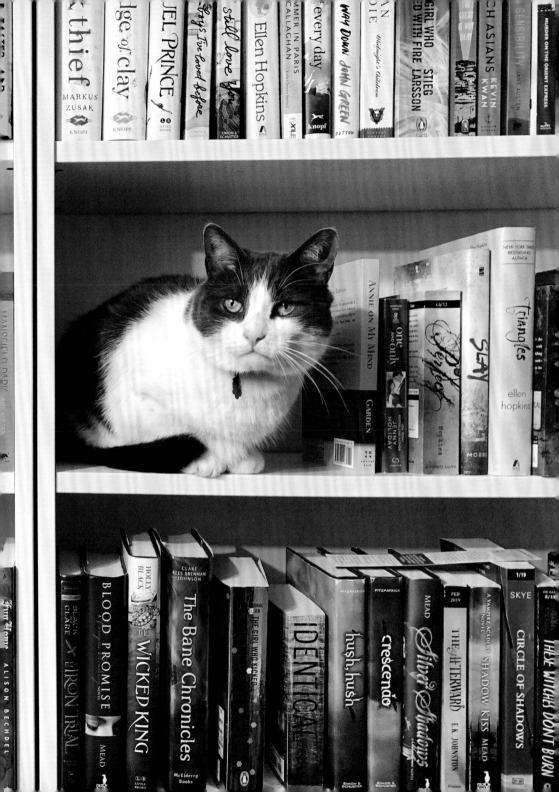

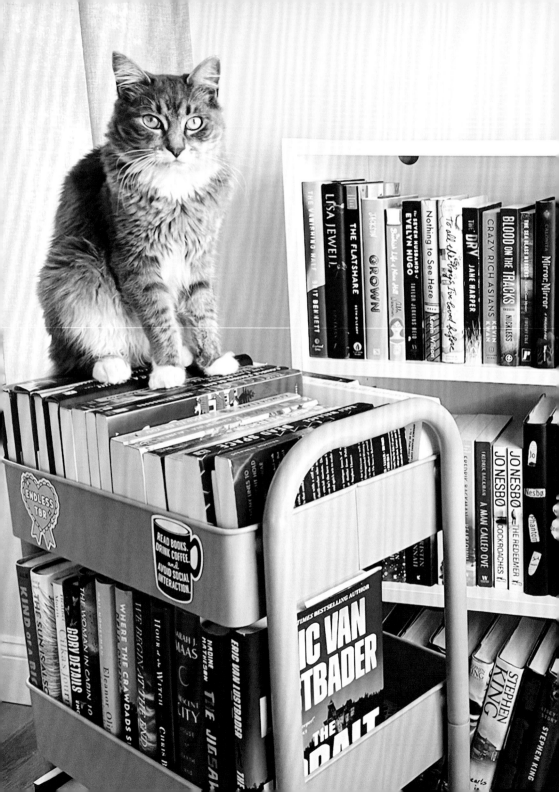

FELIX
Milford, Connecticut, USA

- My nickname is Little Grey!
 I was only 1.2 lb. when my parents
 got me!

- I have a brother named Bigly, a seal
 point Siamese. We love playing with
 each other and are inseparable. Our
 vet says we act like littermates!

- I love snuggling with my mom and
 her fuzzy blankets. I sit with her any
 time she is on the couch.

- My favorite activity is sitting
 next to an open window and
 looking outside.

- My favorite foods are Gravy Lovers
 Fancy Feast and cream cheese.

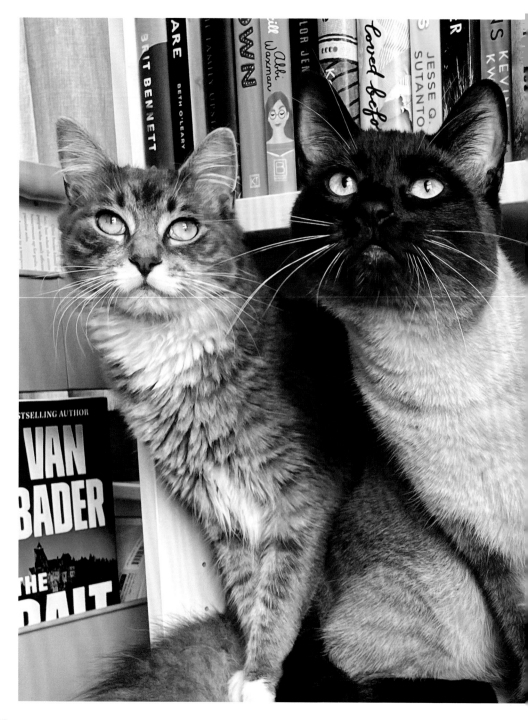

WHAT COMES AFTER
JOANNE TOMPKINS
RIVERHEAD BOOKS

PAULA McLAIN
When the Stars Go Dark
BALLANTINE BOOKS

ARSENIC and ADOBO
Mia P. Manansala

IMPOSTOR SYNDROME KATHY WANG
CUSTOM HOUSE

ANDY WEIR PROJECT HAIL MARY

CAITLIN

CHARLIE
Seattle, Washington, USA

- My favorite napping spot is on the top of my cat tree.

- I can jump so high I almost flip in the air.

- I love putting random objects like toys or hair bands in my water dish.

- I don't snuggle that often, but when I do, I'm very affectionate and sweet.

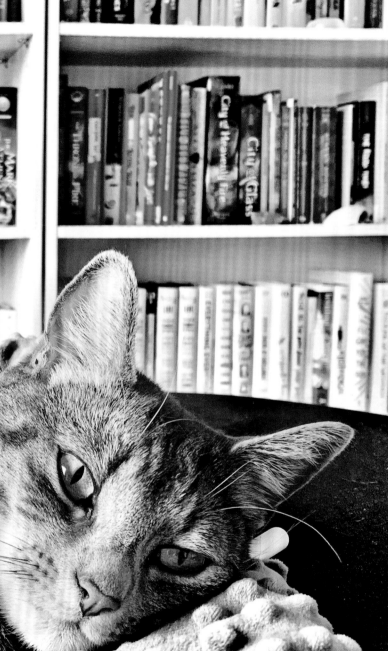

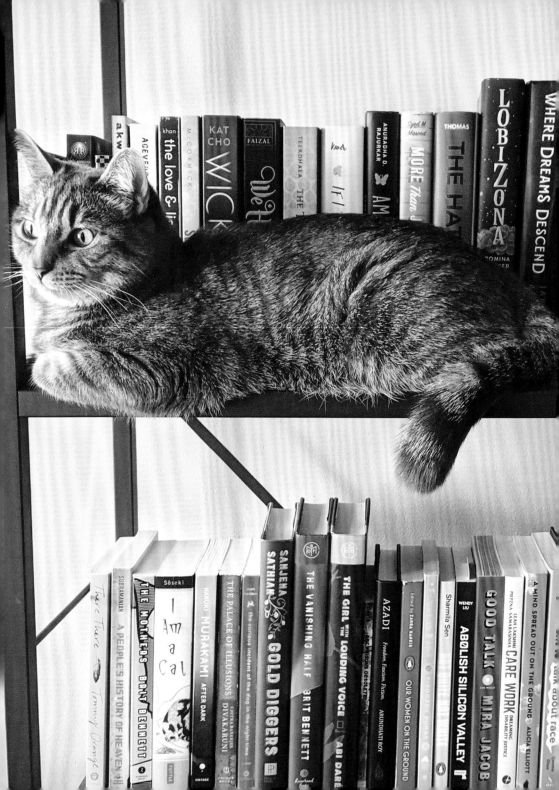

BELLA
Seattle, Washington, USA

- Bella is a gray tabby cat.

- She is two years old but turning three soon!

- She likes to explore outside on a leash and screams in the evening to be taken out.

- She likes to poke your face in the morning to let you know she's hungry.

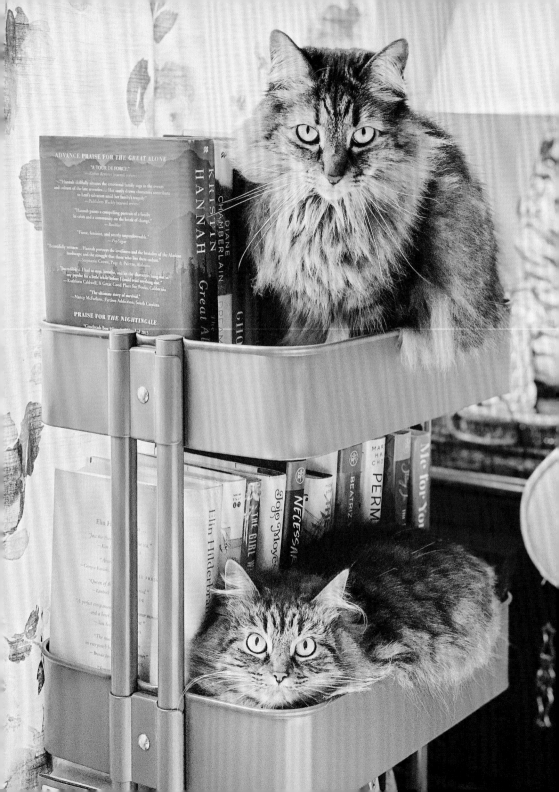

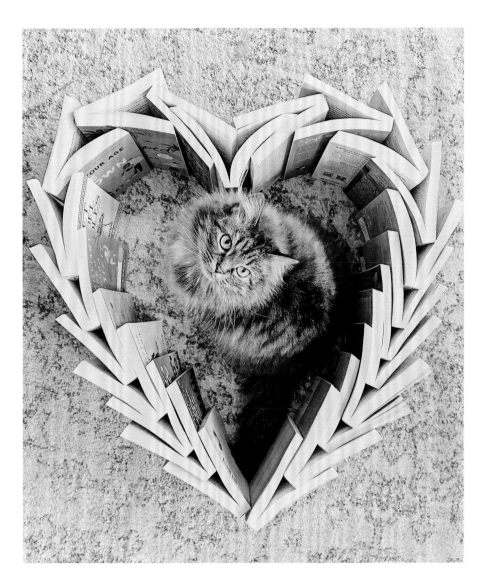

HAZEL & HARRIET
North Carolina, USA

• Hazel and Harriet are both rescues—
 adopted as kittens a year apart.

HARRIET
North Carolina, USA

- Harriet loves to climb the Christmas tree and sleep at the top.

- Harriet prefers to drink water directly from the faucet.

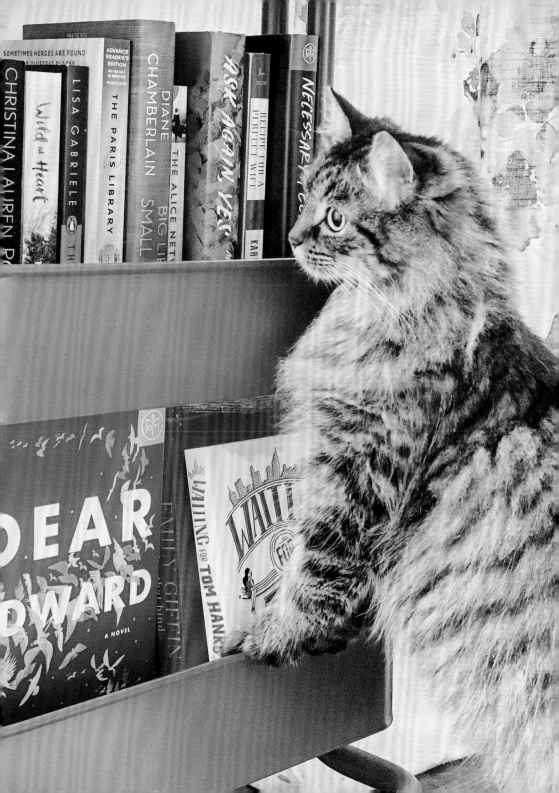

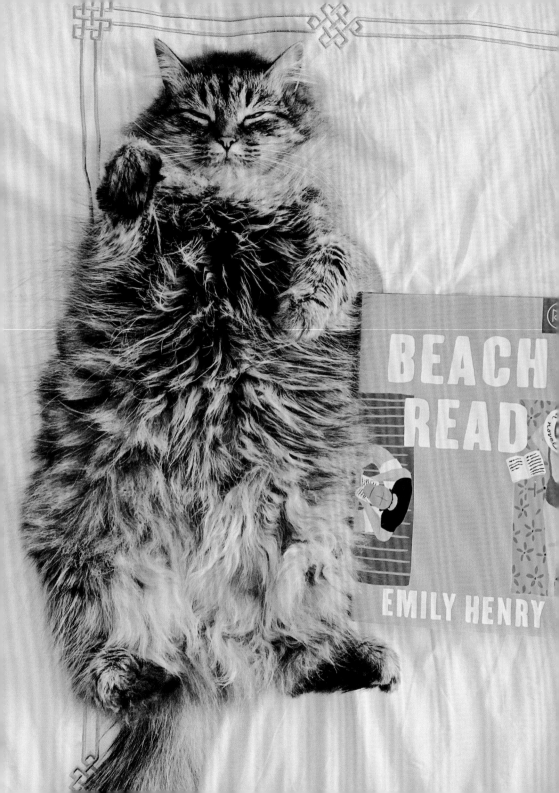

HAZEL
North Carolina, USA

- Hazel regularly climbs into the box spring to hide from Harriet.

- Hazel loves olives more than anything.

MARS, AKA BOOP
Riverside, California, USA

- Will sit by his favorite toy all day, every day to prompt playtime.

- Likes to pretend the drinking fountain is a large body of water and will "sit by the pool" as if it were.

- Will often dip his paws in water to wash.

- Prefers dry food over wet food— go figure.

- Would rather play than eat anything at all.

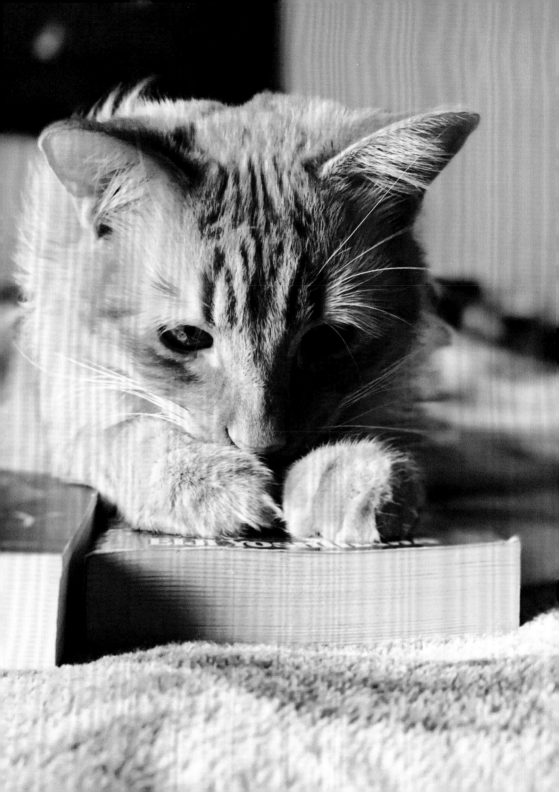

BITSY
Portsmouth, New Hampshire, USA

- She loves strawberries the same way that other cats love catnip.

- She loves to sit on my desk while I'm working and "supervise."

- She's the most loving and cuddly cat that I've ever met, which is so rewarding because she was a very shy, nervous cat when I first adopted her.

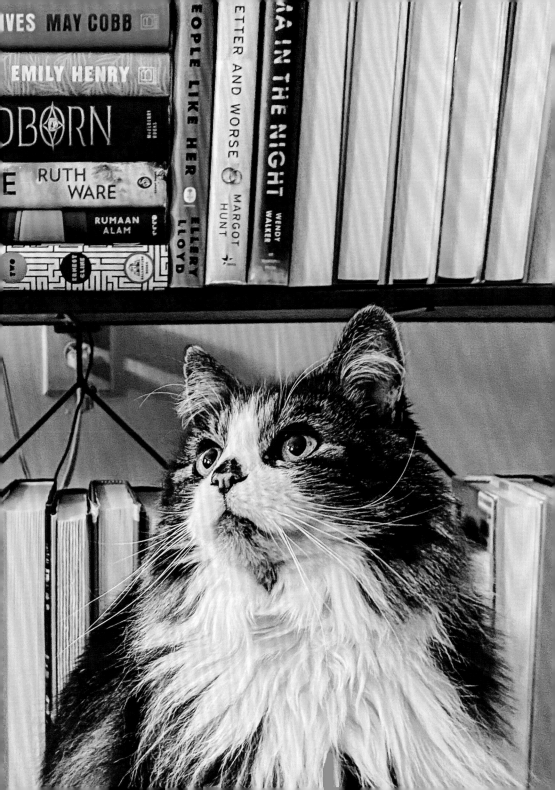

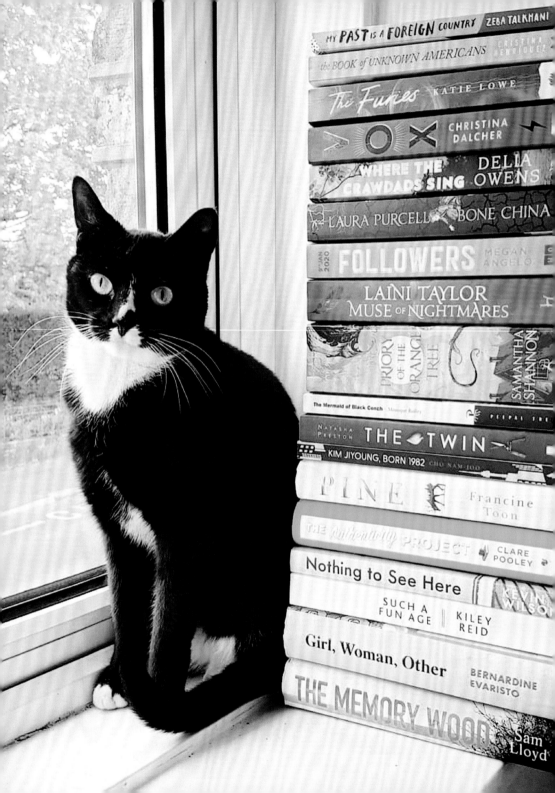

LAYLA WOBBLES, PLAGUE CAT, PRINCESS OF DARKNESS
West Yorkshire, England

- She's a rescue cat—we adopted her when she was about five months old.

- She was brought in as a stray when she was only a couple of months old, so she didn't get properly socialized and sometimes doesn't know how to cat.

- She's very playful. The cat sitter even commented she's the most playful cat she's ever met. One of her favorite toys is a little yarn ball that she carries around in her mouth and will fetch like a dog.

LAYLA WOBBLES, PLAGUE CAT, PRINCESS OF DARKNESS
West Yorkshire, England

- She's completely spoiled; she begs for ham slices, chicken, and second dinner. Her favorite treat is chicken-flavored Dreamies and her favorite wet food is anything fish.

- Because she had toxoplasmosis when she came into the rescue, she continues to be wobbly and is very amusingly clumsy.

- She moves around so much when she's dreaming, she once flew up into the air and flipped over, and still didn't wake up.

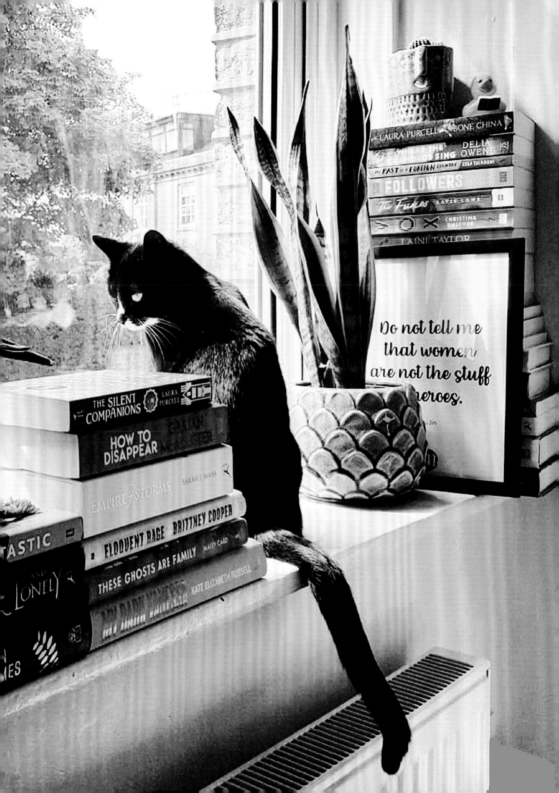

UNKNOWN
Fethiye, Turkey

- I found this cat in a small cozy bookstore/café by the seaside in Fethiye, a town in Turkey. It was a rainy day; I was hiding from the rain and the cat was sleeping so peacefully surrounded by books.

- It's quite a common picture in Turkey, as local people adore cats. Doors of all stores are always open for stray cats, and people feed and pet them all the time. There's also a law protecting street animals.

- Maybe this cat lives in that bookstore; that's also often the case in Turkey. In general, it's a very cat-friendly country.

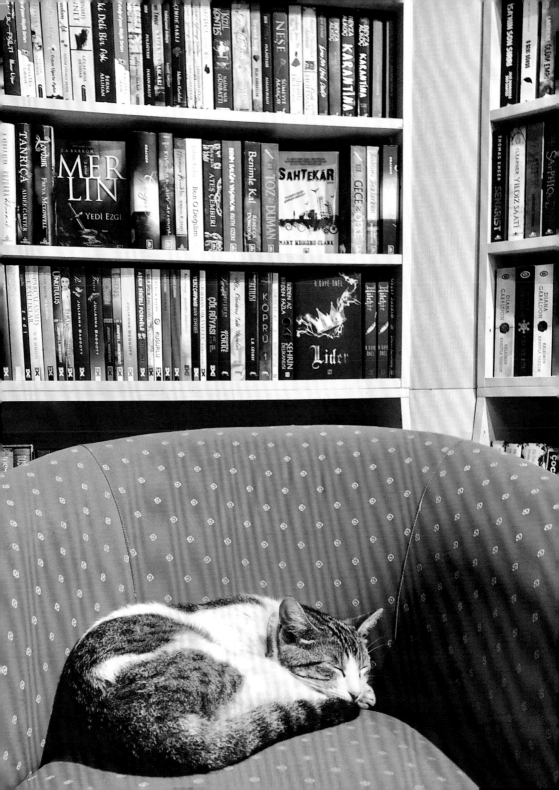

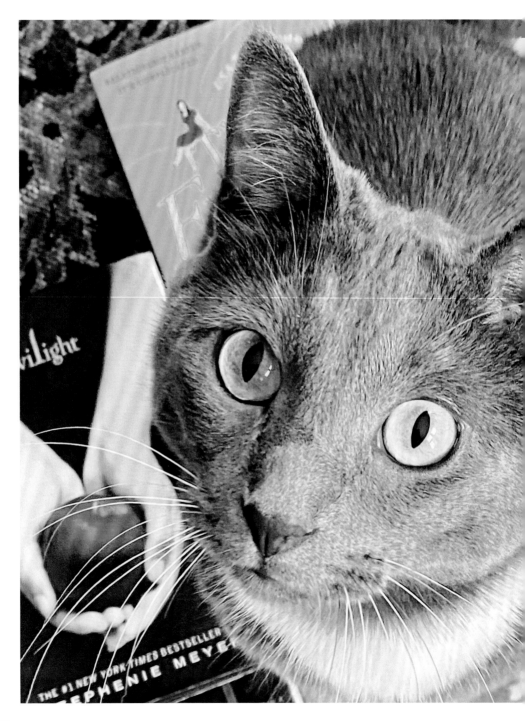

CAESAR
Evanston, Illinois, USA

- Caesar has many nicknames, including Ceez, Mr. C., Ceezy Boy, and Super Cat.

- Caesar is very talkative and especially enjoys singing between 4:00 and 6:00 a.m.

- As an avid birdwatcher, Caesar spends much of his day looking out of the window plotting a way to get closer to his bird friends.

ED
Africa

- Vibrant in personality, can't sit still for the life of him, I always think he was meant to be a dog.

- Most likely to cause a lot of trouble at 3:00 a.m., and he tends to be very loud.

- Attention seeking but in an adorable way.

- His favorite book would probably be *The Great Gatsby*, full of flair, glamour, and drama.

...FATHERS, AND REFORMERS

(b) By others Jesus was regarded not as a second divine Person, but as the one God who had assumed flesh... previously advocated... who came to Rome about A.D.... of Rome... Against Praxeas... preserves the latter's teaching. He maintains that there is one only Lord, the Creator of the world, that the Father himself came down into the virgin, was himself born of her, himself... indeed was himself Jesus Christ.

THE USE OF CREED

For the Instruction of Converts. There are hints in the New Testament that Christians of the apostolic age were instructed in summaries of accepted beliefs (1 Timothy 6...; 1 Timothy 3...; John, verses 9-10; Matthew 28...) baptism a minimum of creed necessary to baptism, and the Didache, admitting to the Holy Communion only those baptized by this formula, stamps it as its creed. From time to time this baptismal creed was expanded. The need of a fuller statement of belief would be felt by each church sooner or later. With all expansions this creed was believed to set forth the teaching of the apostles. The Old Roman Creed is one of these early summaries of faith. It ran as follows:

I believe in God, Father Almighty;
And in Jesus Christ, his only Son, our Lord,
Who was born of the Holy Ghost and the Virgin Mary,
Crucified under Pontius Pilate, and buried:

210

211

tion. He signed a treaty with Charles...

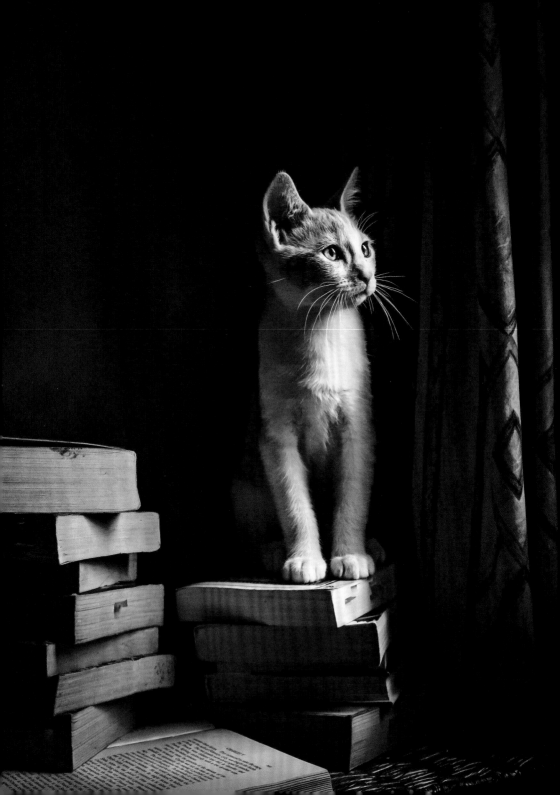

TAN
Africa

- Gentle spirit, very introverted but gets along with the others.

- He has this melancholic look to him. I feel like he was a tortured artist in another life.

- His favorite book would probably be *Stoner* by John Williams or any Woolf.

ATLAS
Africa

- Being the oldest, and the parent of Ed and Tan, she has a very cautious nature. If she trusts you, you are mates for life.

- Ambivert, intelligent.

- She can open doors and hates being left out.

- Her favorite book would probably be *I Capture the Castle* by Dodie Smith, a curious main character.

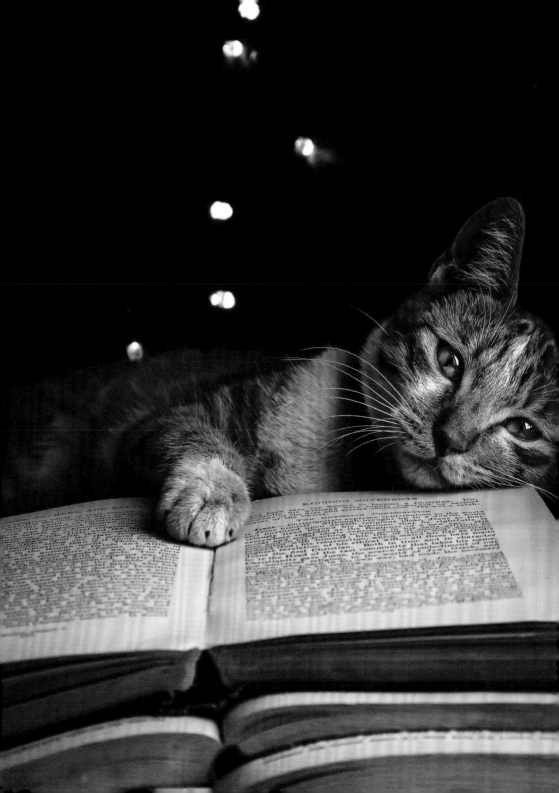

MIOU
Le Havre, Normandy, France

- Miou is a friend's cat, and he's the sweetest cat—intelligent, playful, curious, very affectionate.

- Like many Abyssinian cats, he's got a doglike attachment to his owner—a rare books head librarian.

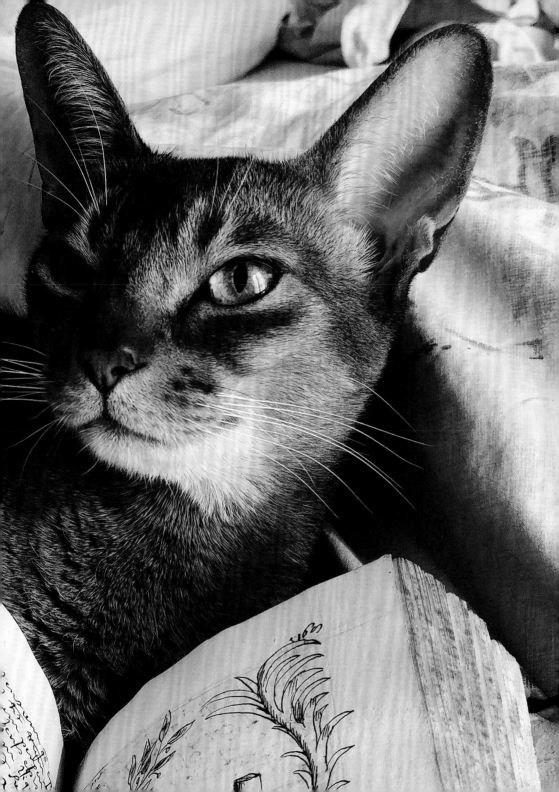

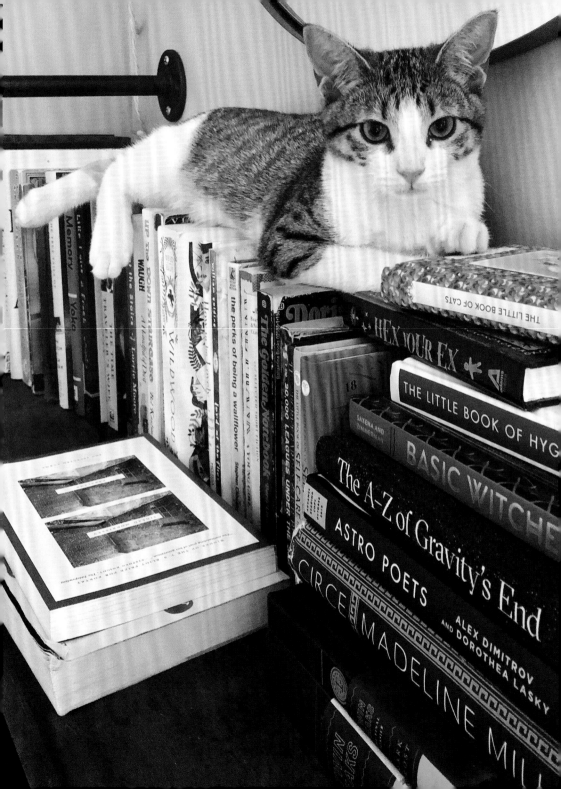

NYLA
Brooklyn, New York, USA

- This was one of our foster kittens, formerly named Noodle!

- As a kitten, her number one pastime was cuddling.

- She's since been adopted, alongside her brother Romulus (formerly Pierogi), and is living out her dreams on a different bookshelf somewhere in Manhattan.

FOX
Bowmanville, Ontario, Canada

- Falls off everything.
- Loves popcorn.
- Morning cuddles are his favorite.

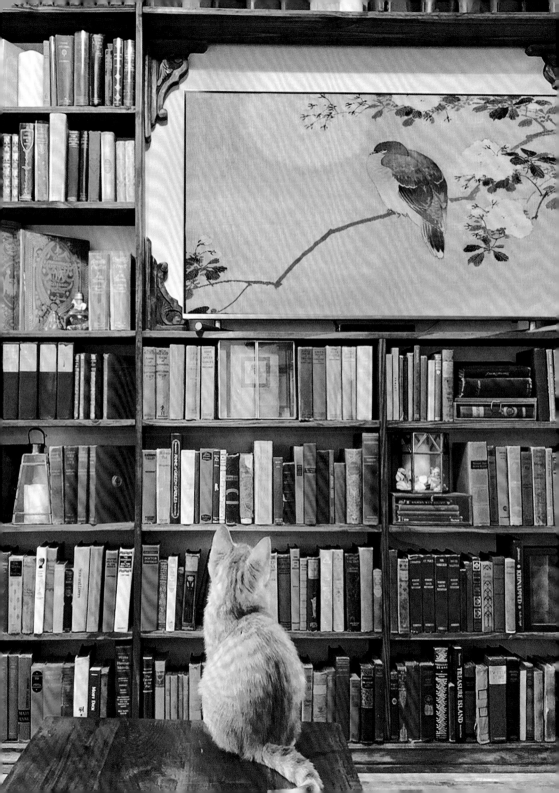

DINGES
*Steenwijk, Overijssel,
the Netherlands*

- Dinges sleeps in every day
 till noon.

- Dinges needs a lot of love and will
 hit you with his cute little paws if
 you walk away after cuddles, since
 he wants more.

- Dinges joins our dog walks
 every day.

- Dinges loves to play cat model for
 all my photos.

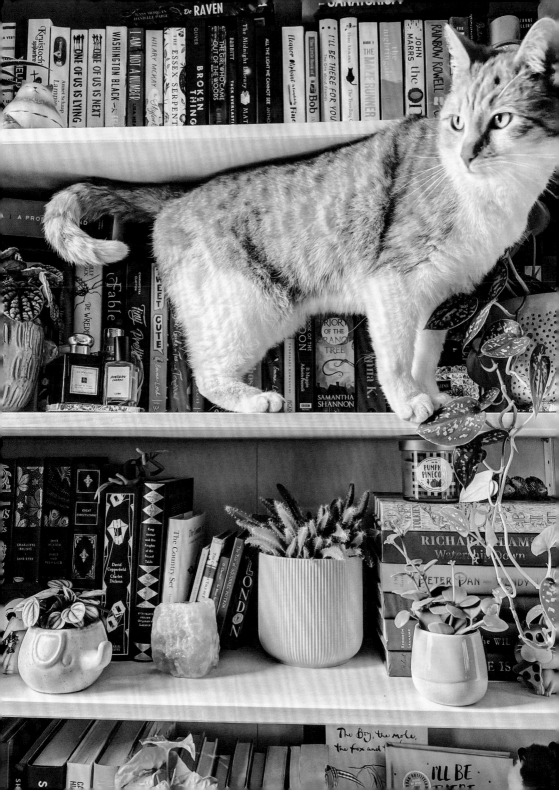

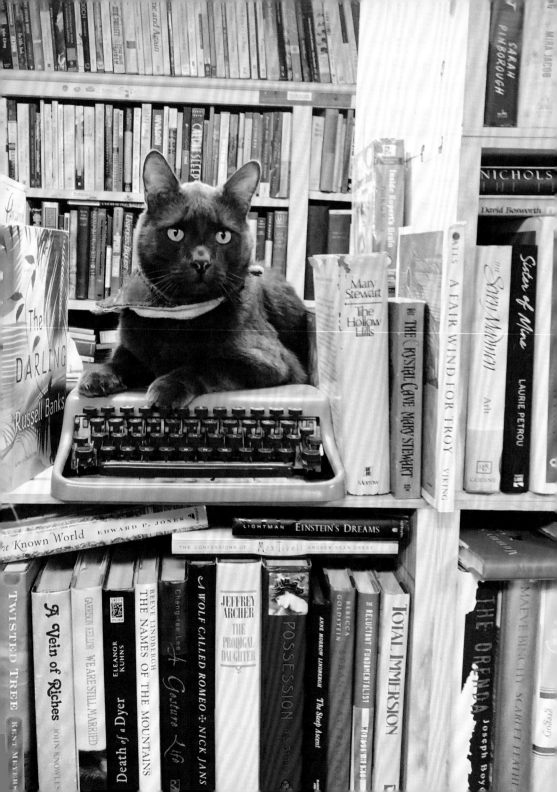

ORSON the BOOKSTORE CAT
Stephentown, New York, USA

- Orson the Bookstore Cat is named after the 1940s actor/writer/director Orson Welles. Orson's human mum loves the Orson Welles movie *The Third Man* as she used to watch it with her father.

ORSON the BOOKSTORE CAT
Stephentown, New York, USA

- Orson the Bookstore Cat has a large collection of bow ties and kerchiefs—he wears a lot of tartan and other plaids as his human mum is Scottish and his bookstore is called Braveheart Books, named after the Oscar-winning film starring Mel Gibson about the fight for Scottish independence.

- Orson the Bookstore Cat is huge! Almost twenty pounds! Not heavy, but like a little panther, and bookstore customers are always taken aback by his size. His girth is in perfect proportion to his charm and silkiness.

- Orson the Bookstore Cat's favorite part of being a bookstore cat is getting to jump in all the book boxes after they are emptied.

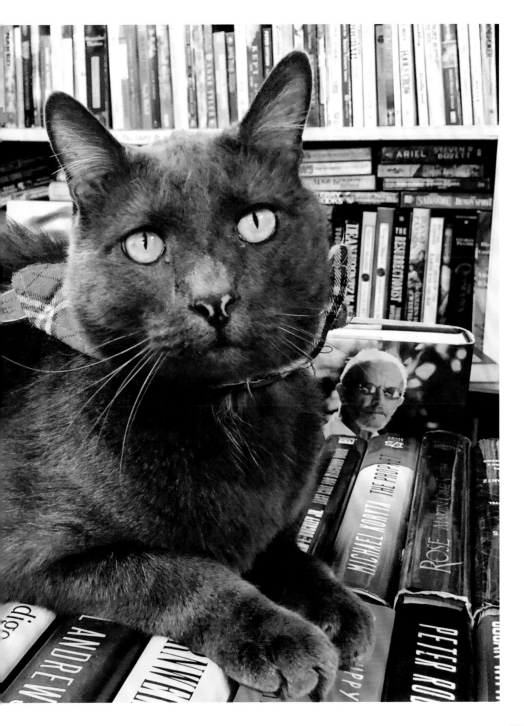

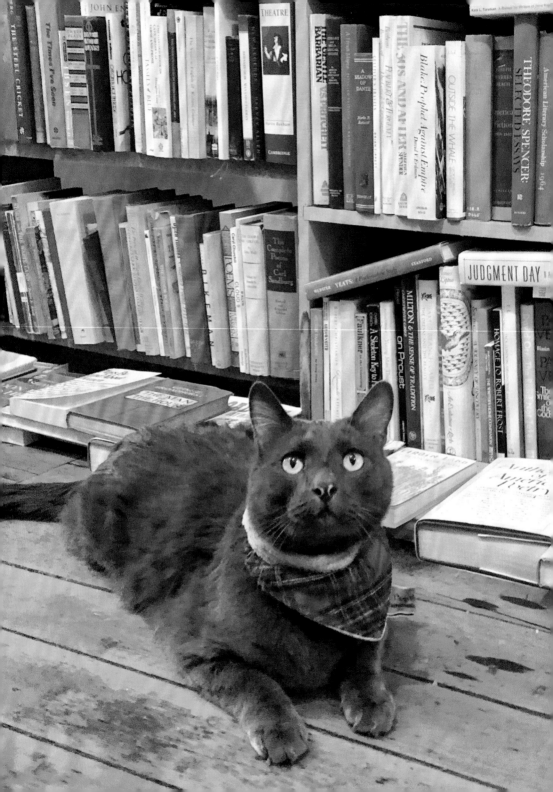

ORSON the BOOKSTORE CAT
Stephentown, New York, USA

- Orson the Bookstore Cat loves wet cat food and has not much interest in human food UNLESS it comes from a bag—popcorn, Doritos, etc. He watches his human mum like a hawk when she eats anything from a bag.

- Orson the Bookstore Cat was born in Fort Lauderdale, Florida, and was given to his human mum as a "breakup" gift after his mum got dumped!

- Orson the Bookstore Cat and his human mum moved from Fort Lauderdale, Florida, to upstate New York and Orson broke out of the cat carrier in the car twenty-five minutes into the nineteen-hour car ride! He spent the rest of the journey sitting in the footwell of the passenger seat and begging for Chik-fil-A waffle fries.

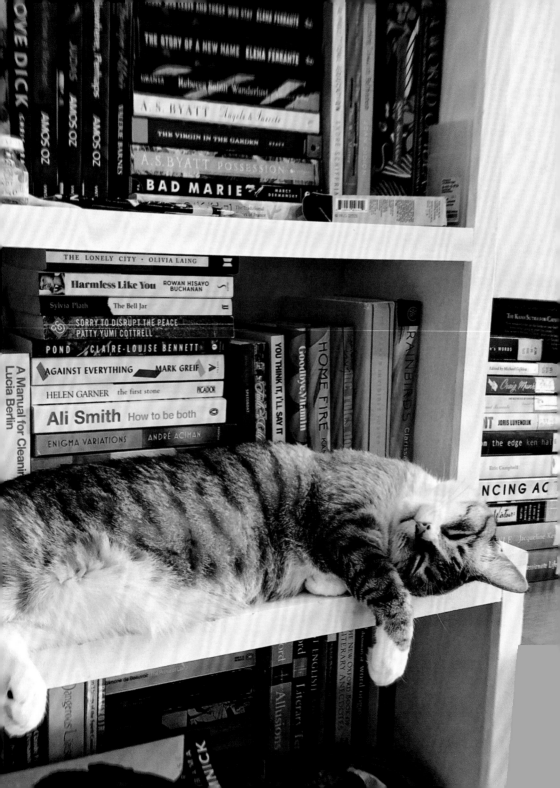

WASABI

Perth, Western Australia, Australia

- As a kitten, she was white. We were told she was half Ragdoll, half Maine Coon. She surprised us by darkening and developing stripes, and we now think she is a lynx point snowshoe Siamese.

- She comes when whistled to, like a little dog.

- Wasabi loves bread and eggs. Nobody can finish their toast without sacrificing some to her.

- She has nystagmus where her little blue irises quiver and shake.

- She is our security system— she hears the tiniest noise and immediately alerts us to anything untoward—even spiders!

- She is deeply affectionate to my partner and me, but terrified senseless of everyone else.

HUGO
Boston, Massachusetts, USA

- I rescued him from the Animal Rescue League of Boston in 2017.

- He won't eat out of a bowl, so he eats his food off of a plate like a person.

- He can catch mice, but he gets scared when they squeak at him so he always ends up letting them go.

- He won't eat any normal people food like fish or chicken, but he goes crazy for SpaghettiOs and tortilla chips.

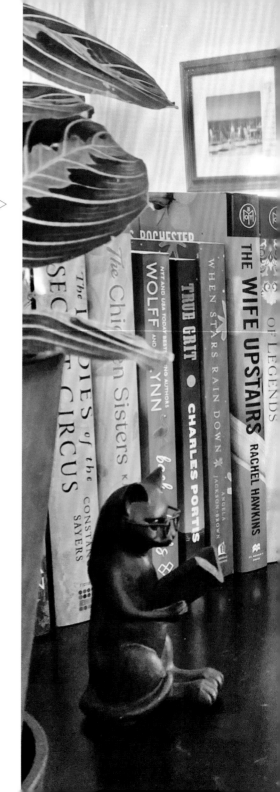

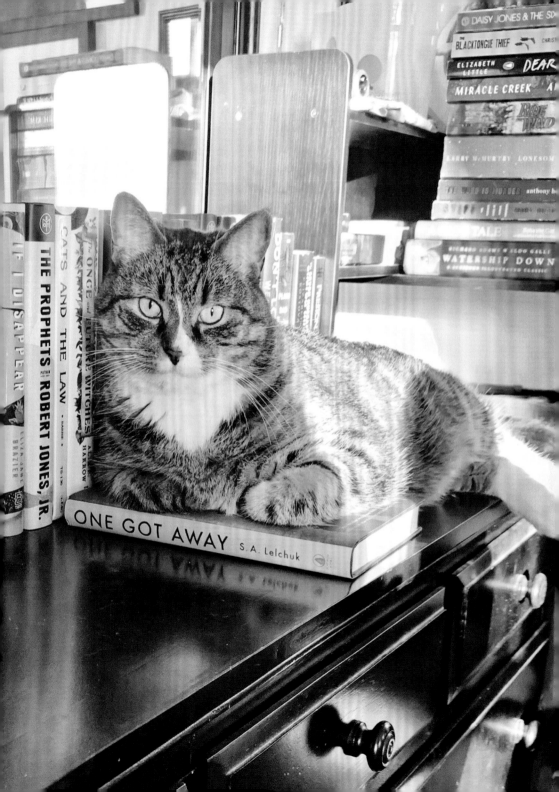

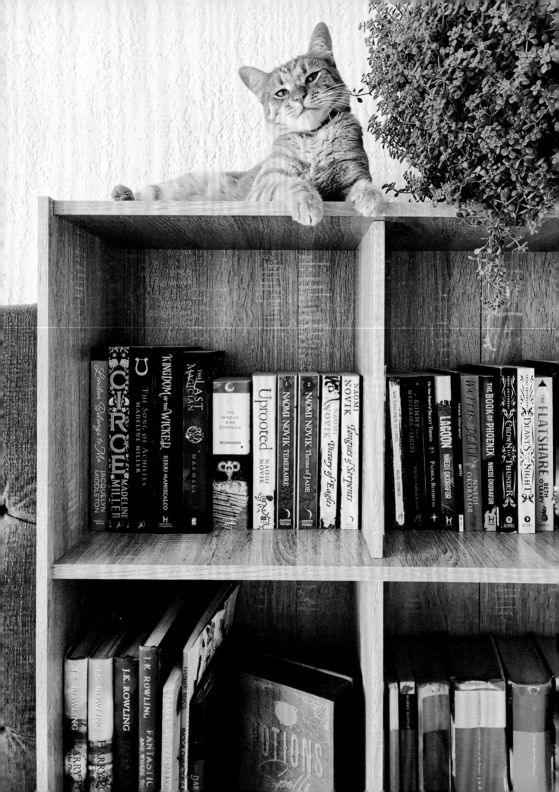

ODIN
Walmer Estate, Cape Town,
South Africa

• Loves to boop his human.

• Addicted to catnip.

• Professional bookshelf climber.

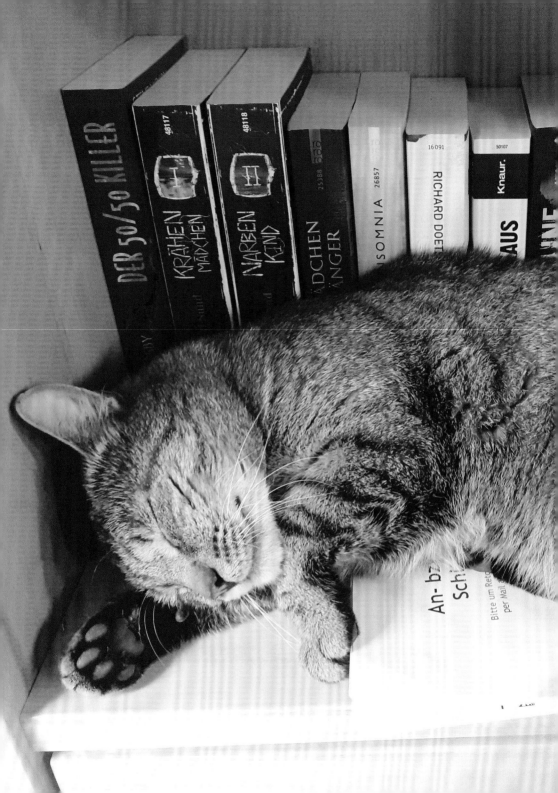

AVIS
Baden, Austria

- He still isn't over the fact that he isn't an only child anymore.

- He has trained my puppy to lie down when he hisses.

- In summer, he brings me a living blind worm at least once a day— I have no idea where he even finds them.

- His favorite places to sleep are in my bed or cuddled up with my clothes.

SAPPHO
Hillsdale, New York, USA

- Sappho belongs to Maureen Rodgers, owner of Rodgers Book Barn in Hillsdale, New York. Maureen founded Rodgers Book Barn in 1972 and has been running it ever since. Sappho arrived two years ago after being fostered by a neighbor. She has taken readily to Barn life.

- She is playful and aloof by turns, friendly with customers and vicious with small mammals who mistakenly cross her path.

- Although she loves being photographed, she loves sleeping and exploring even more.

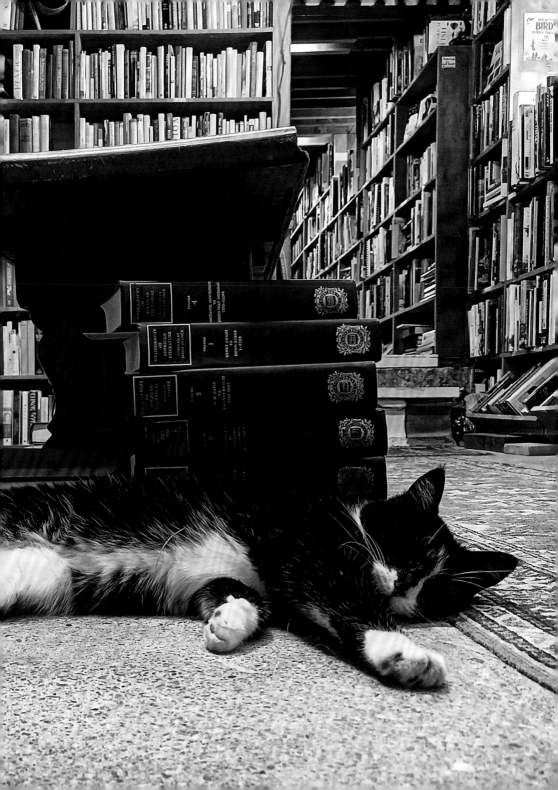

MIMI
Rome, Italy

- Mimi is a rescue cat from a cat sanctuary in the center of Rome called Torre Argentina.

- She loves tuna, playing with her toys, and hanging out with her many books.

- She sometimes also enjoys making a guest appearance on her mum's Instagram page suzannehope1.

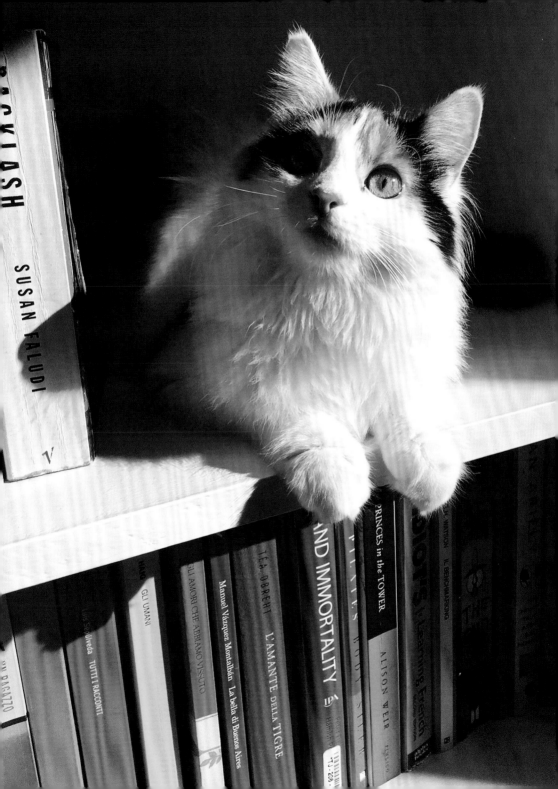

PHOTOGRAPHY CREDITS